# Islamic ceramics

James W. Allan

Series sponsored by

Fine Art Auctioneers

Ashmolean Museum Oxford
1991

To J.R.A.

ISBN 1-85444-001-2 (paperback)
ISBN 1-85444-022-5 (papercased)

Titles in this series include:
Drawings by Michelangelo and Raphael
Ruskin's drawings
Worcester porcelain
Maiolica
Oxford and the Pre-Raphaelites

British Library Cataloguing in Publication Data
Allan, James W. (James Wilson) 1945–
        Islamic ceramics. – (Ashmolean-Christie's handbooks).
        1. Ceramics
        I. Title   II. Series
        738

Cover illustration: Spherical kalian, plate 39

Designed by Cole design unit, Reading
Set in Versailles by Meridian Phototypesetting Limited
Printed and bound in Great Britain by Jolly & Barber Limited,
Rugby

# Introduction

The legacy of the Islamic potters to the world is unique. It was they who first saw the potential of white tin glaze as a 'canvas' for ceramic decoration. It was they who first used cobalt blue on that white ground, and hence invented 'blue-and-white', centuries before such a colour scheme became the trade mark of Chinese export porcelain and then of European taste. And it was they who developed lustre, that extraordinarily luxurious metallic sheen, which rivals precious metal in its effects, all but turning objects of clay to gold.

Without the ceramic tradition of Islam the rise of decorated glazed ceramics in Europe is unthinkable: all their original inspiration and technical knowledge came from the Islamic countries such as Muslim Spain, situated around the Mediterranean. And what would Europe have been like without Maiolica or Delft, Lambeth or Nevers? Without the ceramic tradition of Islam there would have been no incentive for the Chinese to develop their own decorative porcelains, which in the first instance were aimed precisely at the Islamic market. And without that tradition there would have been no 'willow-pattern', or the numerous other Chinoiserie designs which decorate contemporary European china. And here in England Victorian taste was profoundly influenced by Iznik and lustre, as the works of artist potters like William de Morgan vividly illustrate. Without any doubt, our material culture would have been not only totally different, but incomparably poorer, without the existence of the great ceramic tradition of neighbouring Islam.

The reasons why Islamic culture should have reared such a notable tradition are as impossible

to define as the characteristics of its varied ethnic peoples. But three pointers may perhaps help us in our search: a love of colour, a taste for geometry and pattern, and the ability to adopt and adapt.

It is perhaps because so much of the Near and Middle East is desert that colour becomes so important. Towns like Shiraz in south-west Iran epitomise the contrast: the bare hillsides and plains give way to pomegranate groves with their brilliant scarlet flowers, to lush gardens with flower-edged water courses, beds of roses and purple bourganvilleas, to turquoise domes and multicoloured tilework.

The taste for geometry and pattern owe more to the Islamic religious background. It is a common mistake to think that there are no depictions of human beings or other living creatures in Islamic art. A glance at this book will show how totally wrong that supposition is: depictions of human beings abounded in the palaces and more modest homes, just as pictures of national leaders hang in public and private buildings throughout the Islamic world today. But it remains true that in a religious setting such imagery was frowned upon: it is not for man to try to usurp God's role as creator of living things. Because the calligraphing and illumination of Korans and the decoration of religious buildings provided the greatest sources of employment for artists in the Islamic world, non-figural representation inevitably developed at the expense of figural. As a result geometric and floral designs flourished in a way unknown in the icon-orientated Christian world.

The ability to adopt and adapt is probably related to the position of the Near East as a focus for the major trade routes of the old world. The search for wealth and luxuries inevitably led Islamic traders far and wide: across the Mediterranean Sea in the west and the vast Indian Ocean in the east, as far as Zanzibar in the south, and through the steppes of Central Asia in the north. In addition, the European thirst for Oriental silks and spices meant that, prior to Vasco da Gama's rounding of the Cape of Good

Hope, the Islamic world acted as middleman, with all the economic and cultural benefits which inevitably ensued.

The skill of the Islamic potter lies in the way he adopted the Chinese model, and adapted it to his own taste. Time and again we find that imports of Chinese wares acted as catalysts, bringing a profound change in Islamic ceramics through the enterprise of the potters as they tried first to copy, and then to make their own, the ideas that arrived on their doorstep. In the ninth century it was the T'ang white wares that pushed the Iraqi potters into using imitative, white, tin-glaze; in the twelfth it was the import of Chinese white porcelains that led to the development of stone-paste bodies in the Near East as Persian and Egyptian potters tried to emulate the translucency of the Chinese material. But in both cases, by the addition of colour and design, the resulting innovations were developed into something quite unlike the Chinese imports, works of art in their own right with a specifically Islamic character.

It is a matter of great urgency, in these days of international, inter-racial, and inter-religious tension, that Islamic artistic and cultural traditions should be understood and appreciated in non-Islamic areas of the world. It is the hope of the author that this small book will bring to an ever wider public the works of the great craftsman potters of the Islamic past, and that through understanding and appreciation of their unique contribution to the history of world ceramics there will grow a much deeper respect for the Islamic world as a whole.

## 1–2 Two tin-glazed bowls
Iraq ninth century

The import of Chinese white wares and high-fired porcelains into Iraq in the ninth century led the local Arab potters to experiment in reproducing the whiteness of the Chinese originals in their own low-fired pottery. The Iraqi pottery body fired to a yellowish buff colour, and one of the ways the potters developed to make this look white was to cover it with a tin-glaze – a glaze which is made white and opaque by the addition of tin-oxide. This tin-oxide also reflected the eastern trade links of early Islamic Iraq, for, with no tin mines in the Islamic Near East, the metal has to be imported by sea from southern Burma and Malaysia. Occasionally the Iraqi potters were content to leave their products completely plain, like the Chinese originals, but more often they preferred to decorate them, using the white as a ground for blue (cobalt) and green (copper) designs.

These two bowls illustrate four decorative themes typical of early Islamic pottery. The first, which appears on both pieces, is the palmette, traditionally a five-petalled blossom, from which the later 'arabesque' derived (see no. 9). The second is geometry, the central part of the design of the lower bowl being made up of a square within a diamond. The third is stylisation: in the second bowl the highly stylised palmette is about as far from its natural parent as it could be, illustrating a taste common in the Islamic painting tradition as well as in ceramics. Fourthly, the second bowl is decorated with green splashes, a taste common in less expensive pottery objects in an area stretching from Egypt to Iran during early Islamic times (no. 5).

1. Earthenware, blue painting in a white (tin) glaze.
Diameter 13 cm, height 9.5 cm
1978.2137 Reitlinger gift

2. Earthenware, blue painting in a white (tin) glaze, with green splashes.
Diameter 20.2 cm, height 6 cm
1978.2141 Reitlinger gift

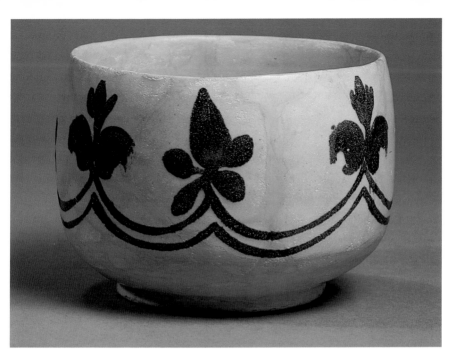

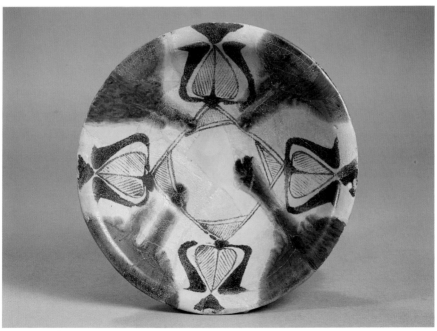

## 3    Lustre bowl
Iraq ninth century

Lustre is perhaps the most important contribution of Islamic potters to the development of world ceramics. The lustre itself is a metallic sheen which was developed and used for its glittering effect, imitating precious metal. A pot was glazed and fired by the normal method; the design was then painted onto the cold glaze surface in a mixture of sulphur, silver oxide and copper oxide, plus red or yellow ochre, suspended in vinegar; the pot was fired a second time, on this occasion at a lower temperature and in a reducing kiln – a kiln with an atmosphere containing carbon monoxide, produced by damp fuel or a restricted air supply. The ochre was then gently rubbed away from the surface of the cooled pot, the decorative design remaining fixed to the glaze in the form of a metallic sheen. Such a sheen is imperceptible to the touch and generally speaking permanent, unless the pot is subsequently buried. In this case the salts in the earth may attack the surface of the object and the lustrous effect will gradually disappear, leaving only a yellowish stain.

The lustre bowl illustrated has a number of interesting features. First of all the background of dots is a derivative of background punching on precious metal, showing the influence of the latter on the lustre tradition. Secondly, under the early Abbasid dynasty, in the ninth and tenth centuries, Iraq was flooded with Turks, imported from Central Asia to provide the mercenaries on which the Caliphs' security depended. The seated figure on the bowl is nothing to do with Islam. On the contrary he is a Bodhisattva, a Buddhist religious figure, typical of eighth century wall-paintings from Central Asia. There such figures often carry a flower in the right hand and a *phurbu,* a ceremonial dagger, in the left. Here, the flower has become highly stylised and the dagger has lost most of its blade. Likewise the peaked hat is impractical, but probably represents the Central Asian *ushnisha.* These features show that the artist did not understand the original image which he was copying. The word *'amal* (made by) in Arabic above the figure's left shoulder shows that he was a local Arab: his name is probably hidden in the design of the bowl.

Earthenware; white (tin) glaze with overglaze lustre decoration.
Diameter 22.8 cm, height 6.3 cm
1956.66 Barlow gift

Bib. G. Fehérvári, Two early 'Abbasid lustre bowls, *Oriental Art* Vol. 9 no. 2 (1963) pp. 79–88.

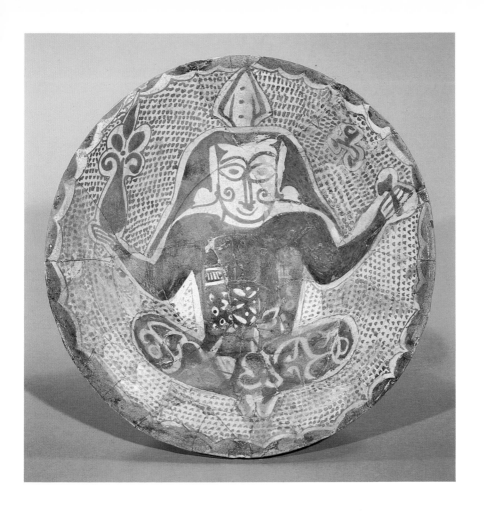

9

## 4    Lead-glazed bowl
Egypt eighth century

Two different traditions of glazing were inherited by the Muslims through their conquest of the Near East in the seventh century. In the east the Sasanian Persians had used a glaze fluxed with soda or potash, called an alkaline glaze. In the west the Romans had developed a glaze fluxed with lead-oxide, called a lead glaze.

The earliest Islamic wares of Egypt continue the latter tradition, but show that a new period of experimentation was under way. For among the 8th century glazed objects given to the Ashmolean from the American Research Centre in Egypt's excavations at Fustat (Old Cairo) is a bowl with a very uneven, speckly, monochrome green lead glaze. This suggests itself as an early experiment with glazing. Secondly there is a fragment with broad stripes in green, ochre and dark brown, suggesting a phase of putting different coloured glazes side-by-side on the same object. Thirdly there is the bowl illustrated here, in which the different glazes – green, brown and yellow – have been used to portray a highly stylised peacock. Although the design itself is remarkably sophisticated, it is evident that the experimental phase is not yet complete, for, alongside the decorated areas, the potter has left parts of the bowl surface completely unglazed.

Earthenware; decorated with green, brown and yellow lead glazes.
Diameter 18.5 cm, height 4.5 cm
1974.48 Gift of the American Research Centre in Egypt; excavated by the ARCE at Fustat 1972.

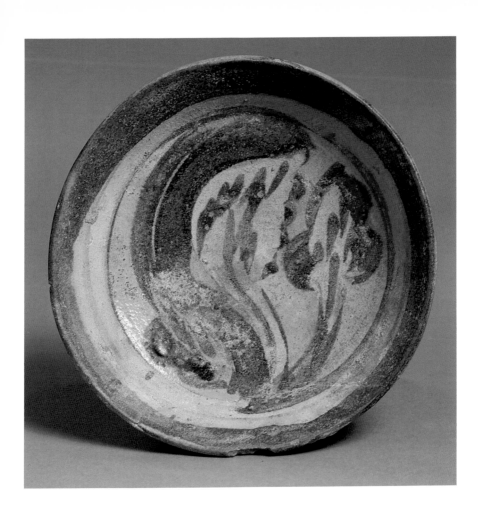

## 5    Sgraffito bowl
Iran tenth century

'Sgraffito' comes from the Italian *sgraffire*, 'to scratch', and refers to the technique, common in Islamic pottery, whereby the object is covered with a thin clay slip, and the design is then incised through the slip before the glaze is applied. If, as on this example, the body of the pot is buff, the slip white, and the glaze virtually colourless, the incised lines will appear a buff colour against the white ground.

In the centre of this bowl the potter incised a six-petalled rosette within a hexagon. He slightly misjudged the eight-pointed star pattern he had in mind for the sides of the bowl, and drew nine instead: each contains a briefly sketched bird. The coloured splashes, in iron brown and copper green, were perhaps intended to complement the octagon, but end up by creating their own emphases. The result is poorly integrated, and seems to hang together more by chance than design. Such a loose style was, however, very popular in the Islamic world, and the overall effect of such a bowl is quite delightful.

Sgraffito wares of this type came into fashion in Iraq and Iran in the tenth century. Less demanding artistically and technically than those painted with cobalt blue designs or lustre, they provided the decorative glazed wares for large numbers of less affluent town and village dwellers, and formed a ceramic underworld which continued for centuries.

Earthenware; design incised through a white slip under a yellowish transparent glaze, splashed with green and brown.
Diameter 22.5 cm, height 6.3 cm
1978.1759 Reitlinger gift

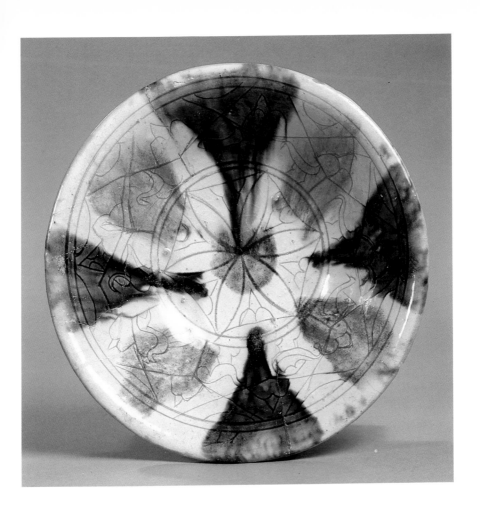

## 6    Slip-ware bowl
North-east Iran tenth century

A slip is a semi-fluid coloured clay used either for coating an earthenware vessel or for decorating it before glazing. Here the body of the bowl is buff, and has been covered with a white slip as a ground colour. A thick brown slip has been used for the painted design and the pot has finally been covered with a transparent yellow glaze, giving it a visually robust impact. Slip painting was very common in North-east Iran and Transoxania (the lands beyond the Oxus) in the ninth – tenth centuries, under the Samanid dynasty, and less pretentious products using the same technique are found throughout central Iran during the same period.

The design combines the Islamic taste for radial designs on ceramics, in particular stellar and cruciform patterns, with calligraphy. A cruciform ornament dominates, but as so often in Islamic pottery, a secondary cross fills out the spaces, thus completing the effect and providing the visual balance evidently desired by both craftsman and client. The calligraphy on this bowl is difficult to recognise, but the thinly-painted filler ornament of the central circle and of each radial segment is in fact derived from *kufic* (geometrically-formed) Arabic script. It cannot be read, but it was probably intended to convey, symbolically, the good wishes which such inscriptions normally contained.

Earthenware; decorated in brown slip under transparent yellow glaze.
Diameter 25.9 cm, height 7 cm
1956.91 Barlow gift

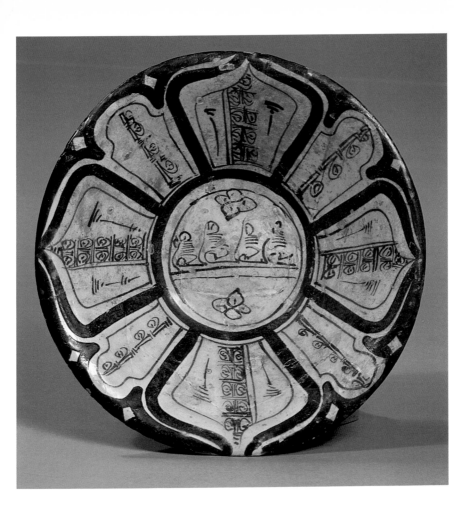

## 7    Octagonal vase
Iran twelfth century

This vase is made of an artificial ceramic body known as stone-paste, or frit-ware. According to a member of a medieval Persian family of potters, Abu'l-Qasim Kashani, this ceramic body was made of ten parts of ground quartz, one part of ground glass frit, and one part of fine white clay. It was almost certainly developed as a medium for pottery in Islam as a way of imitating the white translucency of Chinese porcelain. Once introduced, probably in the eleventh century, it proved to be immensely popular, and is still used by some contemporary Iranian potteries. Stone-paste is difficult to throw, and the objects made of it were therefore usually moulded. As a result bowl forms tended to standardise.

The eight sides of this bowl are decorated in succession with pairs of figures, either sphinxes or horsemen, of great antiquity in Iran. Sphinxes were used as symbols of good-luck in medieval Islam, and iconographically derive from the sphinxes which still adorn the carved stone remains of the great palace of Persepolis near Shiraz, founded by King Darius in the sixth century BC, and set on fire by Alexander the Great's troops in 330 BC. The paired horsemen probably derive from a more than life-size carving which adorns the great rock face at Naqsh-i Rustam, near Persepolis. Dating from the third century AD, it shows Ahuramazda, God in the Zoroastrian tradition, handing the Sasanian King, Ardeshir I, the ring of investiture. Like Persepolis, Naqsh-i Rustam remained a centre of national mythology throughout Islamic times: both sites are alluded to in the literature, and were regularly visited by kings and commoners alike.

Stone-paste body; moulded decoration under transparent blue alkaline glaze.
Height 13.7 cm, diameter 18.2 cm
X 1206

Bib. J.W. Allan, Abu'l-Qasim's treatise on ceramics, *Iran* Vol. 11 (1973) pp. 111–120.

**16**

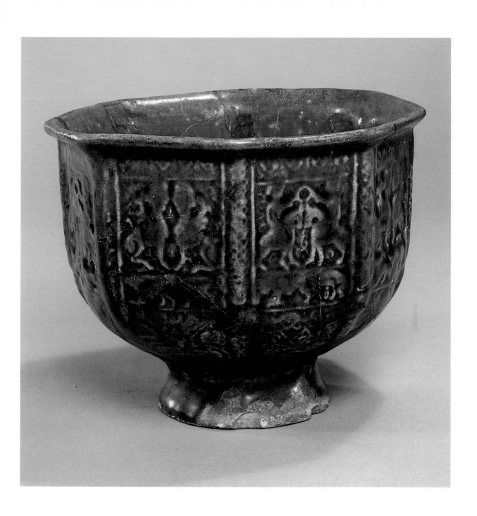

## 8   Jug
Iran twelfth century

After initially using the stone-paste body to imitate the white Chinese porcelains, the Islamic potter in his accustomed way started to add colour. First he added a single colour to the glaze – cobalt for blue (no. 7), manganese for purple, or, as here, copper for turquoise. In a lead glaze copper turns green (no. 4), but in the alkaline glazes used on stone-paste it turns turquoise, and it is this turquoise which has been the hall-mark of Persian ceramics and tiled domes ever since its introduction in the eleventh – twelfth century.

The design on the jug is calligraphic, using a stylised *kufic* script. Calligraphy was of far more importance in Islamic culture than in the Christian west. The Arabic text of the Koran was considered to be a transcription of an eternal Koran, written in Arabic, kept in Heaven. The words and letters thus had a holiness of their own. Taken alongside the antipathy towards the use of images in a strictly religious context (p. 4), this explains why the decorative possibilities of the Arabic script were so fully explored by Islamic artists, and accounts for the popularity of calligraphic designs in media, like ceramics, less suited to them. Here the Arabic words for 'glory' and 'prosperity' are recognisable, but the rest is illegible, and the whole gives the impression of having been designed by an illiterate craftsmen. His customers, however, would have been uplifted by the presence of the Arabic script on their purchases, and even if they too were illiterate, would have taken it as symbolising the good wishes which were the potter's original intention.

Stone-paste body; moulded decoration under transparent turquoise alkaline glaze.
Height 21.8 cm, diameter of mouth 9.2 cm
X 3110

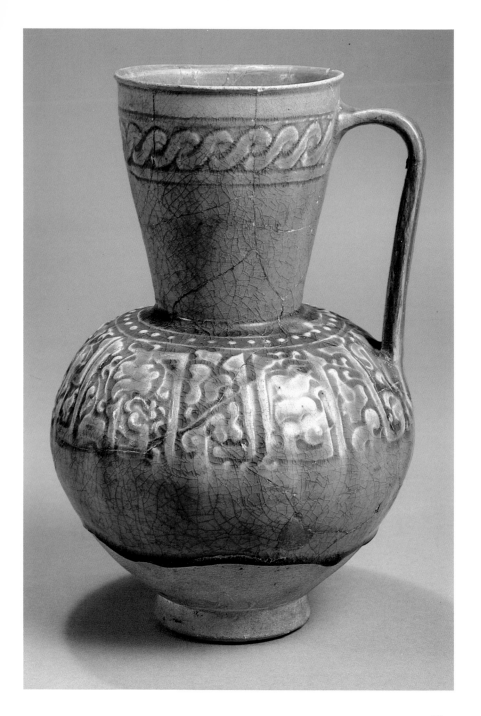

## 9  Footed dish
Iran twelfth century

This footed dish belongs to a group of ceramics commonly known as 'silhouette ware'. Like no. 6, it is decorated with a clay slip. Here, however, the slip is not used for painting. Instead the object has been dipped into a thick black slip, and when dry the slip has been carved away to leave the design in relief on a white ground. The subsequent turquoise glazing gives the dish its final, black and turquoise, colour scheme.

Once again we see the Islamic taste for balanced geometric forms around a central point. Here, as in no. 6, the design is cruciform, this time each arm a palmette within a heart-shaped cartouche, the cartouches themselves being formed by half-palmettes. The half-palmette is the basis of what we, in the West, call the 'arabesque'. To form a simple arabesque, split a palmette down the centre lengthwise. Now attach the resulting half-palmettes to an s-shaped stem in such a way that the half-palmettes are in line with one another, but on alternate sides of the stem. There are of course infinite variations on this theme, depending on the form of the original palmette and the space needing to be filled by the resulting arabesque.

Stone-paste body; decorated in black slip under transparent turquoise alkaline glaze.
Diameter 20 cm, height 5.6 cm
1956.130 Barlow gift

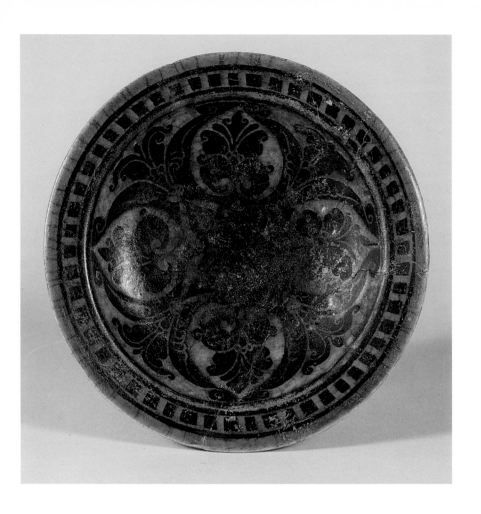

## 10    Underglaze-painted bowl
Iran (Kashan) early thirteenth century

Painting in blue and black under the glaze was a technique developed round about 1200 AD in Iran. The immediate precursor of the technique seems to have been painting in black slip under a clear or transparent turquoise glaze, the so-called 'silhouette ware' (see no. 9). The thickness of the slip and the carving technique employed in the latter wares lent itself to broad, boldly-conceived designs, but was unsuitable for more precise painting and for the sorts of designs which were becoming popular in illustrated manuscripts. In order to meet this challenge the potters first developed underglaze-painting, and later overglaze-painting (see nos. 13–14). In underglaze-painting the blue derives from cobalt oxide, and the black from a mineral containing iron, manganese and chrome mined near Kashan in western Iran. The important discovery of the potters was that both these pigments are relatively stable under an alkaline glaze.

The design on this bowl shows the way the blue and black were normally used, the blue for broader bands, the black for detailed work. Here the central motif is the face of the Sun. Medieval Islamic society took astrology very seriously, and numerous objects were decorated with the Sun and the other planets, or with the signs of the zodiac (see no. 16). In contemporary metalwork, where more elaborate designs were laboriously worked out in silver and copper inlays, the Sun is normally surrounded by the other six known planets, the Moon, Mercury, Venus, Mars, Jupiter, and Saturn. In ceramics the tendency in decorating was always towards a shorthand, and here the Sun is probably meant to bring to mind the whole of the heavens and the good fortune which might thereby accrue to the owner of the bowl.

Stone-paste; decorated in blue and black under a colourless alkaline glaze.
Diameter 19.3 cm, height 10 cm
1978.2311 Reitlinger gift

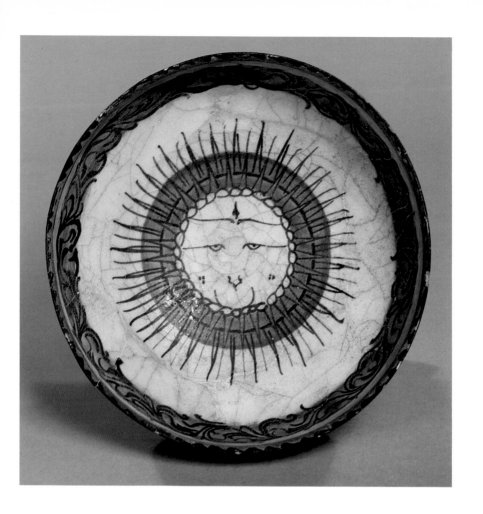

## 11–12 Bowl and tankard with blue stripes
Iran (Kashan) early thirteenth century

The influence of metalwork recurrs in Islamic ceramics. Here a small but interesting feature derived from metalwork is the latch handle on the tankard, which was common on earlier bronzes and contemporary inlaid brasses but is a somewhat impractical shape in clay.

The frit ware bodies of the tankard and bowl are used to good effect as a white ground for the bright blue stripes under the glaze. The use of such stripes gives the pieces a very modern look, and indeed they were probably appreciated in the 13th century as they are today for their very abstract designs. In a medieval Islamic context, however, they were also almost certainly interpreted in a symbolic way. The symbolism of the Sun has already been discussed (no. 10). Here the radiating blue lines on the bowl remind us of the Sun's rays, and the solar symbolism is further enhanced by the central bird figure. For the ability of birds to fly up into the sky relates them to the heavens, and it is of course in the heavens that the Sun has his residence.

11. Stone-paste, decorated in blue under a transparent alkaline glaze;
height 9.2 cm, diameter 20 cm
1978.2341 Reitlinger gift

12. Stone-paste, decorated in blue under a transparent alkaline glaze;
height 12 cm, diameter 16 cm
1978.2347 Reitlinger gift

Exterior of bowl
1978.2341

24

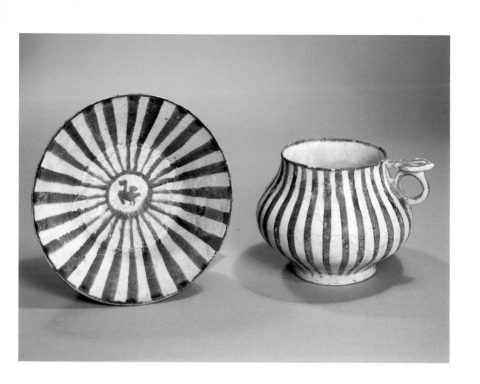

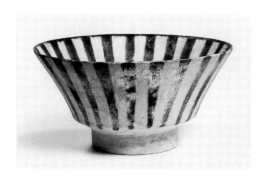

### 13–14 Two 'Minai' bowls
Iran (Kashan) early thirteenth century

Book painting, both illumination and illustration, had a marked impact on the decorative ceramic tradition of the Islamic Near East in the twelfth and thirteenth centuries. The underglaze-painting technique (see no. 10) had one serious limitation – colour: it was confined to blue and black. In northern Iran, probably in Kashan, was developed the technique of overglaze painting, painting onto the cold glaze with enamel colours which were then fixed in a final, low temperature firing. This enabled the potters to copy and develop the more highly-coloured, artistic ideas already in use among book painters. Objects decorated in the overglaze technique are normally called Minai-ware, from the Arabic word *mina*, 'glaze'.

On the upper bowl the blue is under the glaze, the gold and red over it. The central geometric design is probably inspired by a Quranic frontispiece, while the gilded letters, their red outlines, and the four ornamental dividers can also be compared to the calligraphy and illumination of luxuriant Quranic manuscripts. The words on the inside of the rim, in *kufic* (geometric) script, are purely ornamental. Those in cursive script on the inside of the body, on the other hand, wish the owner good fortune, using such sentiments as eternal glory, increasing prosperity, happiness, peace, generosity and perpetuity!

In contrast, the two figures on the lower bowl most probably derive from textile designs, in which symmetrical compositions have great technical, and therefore economic, advantages. Moreover, paired horseman or paired, confronted animals and birds, are common on surviving, early Islamic silks. 'Minai' ware was thus drawing not only on illuminated manuscripts, but also on contemporary luxury textiles.

The two figures are probably not part of any specific story or legend. More likely they are to be seen as symbols of the ease and well-being that accompany the courtly life. Their symbolic message is then enhanced by the words of good fortune – peace, well-being, joy, happiness and so on, on the inside of the rim.

13. Stone-paste; transparent alkaline glaze with underglaze painting in blue and overglaze painting in red and gold.
Diameter 21.3 cm, height 9.5 cm
X 3012

14. Stone-paste, painted in underglaze blue and overglaze green, red, brown and black.
Diameter 19.2 cm, height 8 cm
1956.36 Barlow gift

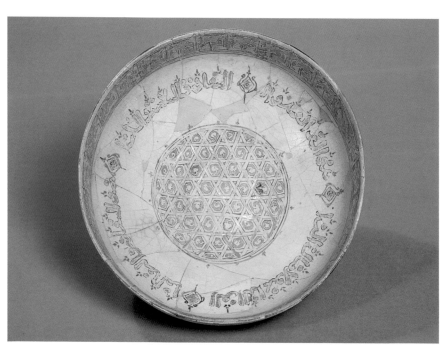

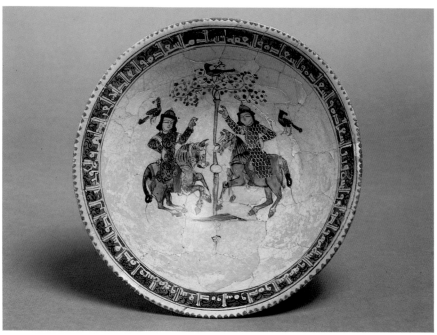

## 15    Lustre bowl
Iran (Kashan) dated 608/1211–12 AD

Lustre, having first been used on glazed pottery in ninth century Iraq (no. 3), became very popular in the tenth – twelfth centuries in Fatimid Egypt, and then reached new heights in late Saljuq Iran round about 1200 AD, just before the Mongol invasions. Lustring seems to have been a secret process, confined to a small number of families, which could only become known in some new cultural setting when the craftsmen themselves moved and took the secrets with them. The centre of the Persian industry became Kashan, and the most famous of the craftsmen were the Abu Tahir family, at least three generations of which are known to have produced tilework, and presumably pottery, over a period ranging from 1206–1327. This bowl is unsigned, but is dated to the Islamic (Hegira) date 608, equivalent to 1211–12 AD.

In style the bowl is typical of the period from 1199–1226: the heads and hands of the figures are in reserve, but their costume is densely covered, as is the background, with tightly wound spirals. Who the six figures contemplating the stream or fish-pond are, we shall probably never know, but we can immediately recognise the skill of the artist in the way he has fitted them so elegantly into the circular, curving surface of the vessel. We should also notice the figures' moon-faces, introduced from Buddhist art by the Saljuqs, through which the artist irradiates the design with an extraordinary peace and serenity.

Stone-paste; decorated in golden brown lustre over the glaze.
Diameter 20 cm, height 10 cm
1956.33 Barlow gift

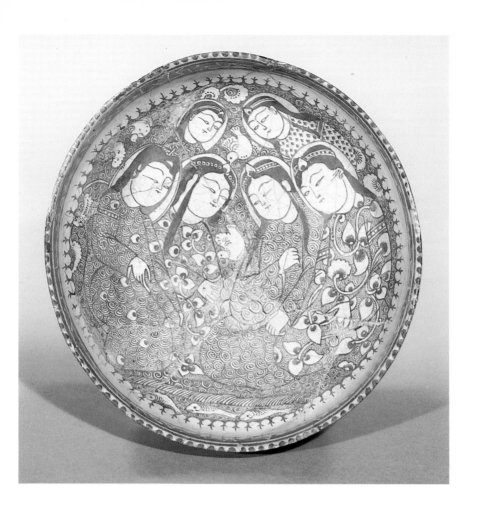

## 16    Lustre jar
Iran (Kashan) early thirteenth century

On this second example of Kashan lustre, the influence of the book painting tradition is clearly to be seen. Astrological miniatures in roundels are known from extant medieval manuscripts, and the cross in reserve used as a background pattern for the roundels is derived from a similar design used in Quranic manuscripts as a background for script.

The sun and its symbolism have already been illustrated (no. 10). On this jar we find the twelve signs of the zodiac: (reading from left to right) Cancer, Gemini, Taurus, Aries, Pisces, Aquarius, Capricorn, Sagittarius, Scorpio, Libra, Virgo and Leo. From Capricorn to Libra are reconstructions, as that part of the vessel is largely missing. Of particular interest in an Islamic context is Virgo, who is shown here as a seated figure holding what is probably a handful of corn in her right hand, and a cutting implement in her left. This imagery stems from her Arabic name, *al-sunbulat,* which also means 'an ear of corn'. Aquarius is normally shown drawing water from a well, but here the artist seems to have been satisfied with a very sketchy water bottle in the figure's right hand.

Medieval Islamic society was clearly very superstitious. In European society today astrological superstition normally focusses on the zodiacal sign under which the individual was born, hence the mugs, key-rings and the like decorated with a single zodiacal image. In early Islam the birth sign of an individual was also significant. But the use of that specific image in an artistic context seems to have been unusual, and almost all surviving objects with zodiacal decoration bear the full range of twelve signs.

Stone-paste; decorated in brown lustre over the glaze.
Diameter 12 cm, height 7 cm
1956.58 Barlow gift

Signs of the zodiac:
Virgo, Leo, Cancer,
Gemini, Taurus, Aries,
Pisces, Aquarius.

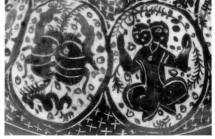

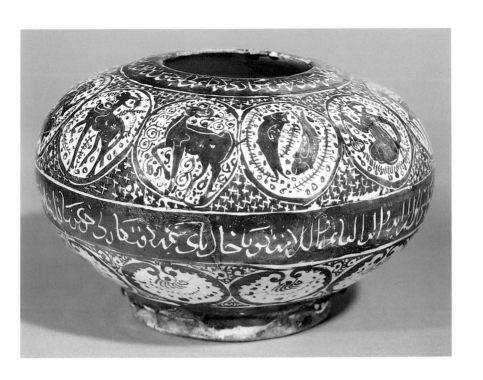

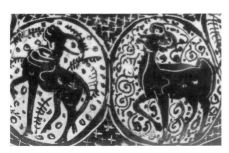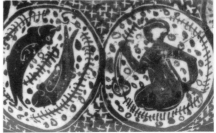

## 17–18 Two underglaze-painted bowls
### Iran (Kashan) late thirteenth century

The underglaze painting tradition, once developed, was to have continuing use in Islamic ceramics, and changes in style and colour scheme mark successive phases. Under the Il-Khanid (Mongol) rulers of Iran in the late thirteenth century the style of vegetal design becomes looser and more fluid, the variable but distinct background patterns of the pre-Mongol period become loose groupings of dots, and the black becomes much softer and greener in colour. Occasional blobs of turquoise indicate an interest in expanding the underglaze palette. Figural decoration declines, and the commonest designs are now geometric, with a variety of arabesque patterns used as fillers. Both these bowls have radial designs. No. 17 has a 'Maltese' cross which is emphasised visually by its colour, by its wide, white border, and by the wide, white surround to the pear-shaped cartouches in each of its arms. In no. 18 the centre has a greater emphasis, and the balance of the now eight radiating panels is more subtle. The primary cross-shape is emphasised by its pointed arms, and by the use of the same arabesque design as a filler for each of them. The four secondary arms have square ends and the designs used as fillers alternate, two and two. The result is that although the bowl is decorated with an eight-pointed radial design, the eye reads it as a cross.

17. Stone-paste; painted in greenish black, turquoise and blue under a transparent glaze.
Diameter 21.8 cm, height 10 cm
1978.1638 Reitlinger gift

18. Stone-paste; painted in greenish black and blue under a transparent glaze.
Diameter 21.4 cm, height 9.7 cm
1978.1595 Reitlinger gift

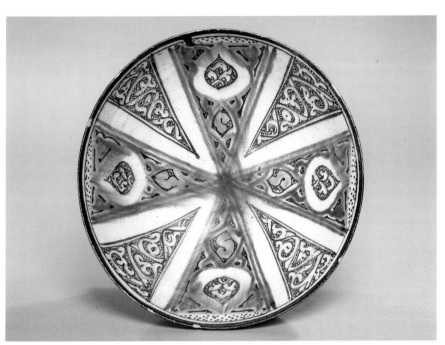

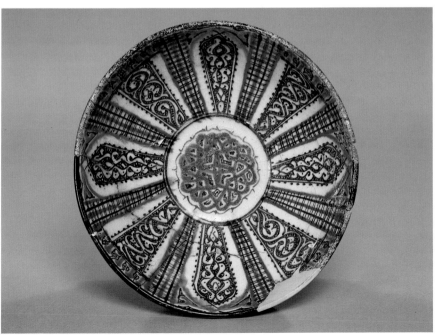

## 19 'Sultanabad' bowl
North-west Iran c.1300

The Il-Khanid period saw the introduction into Persian art of a group of important decorative motifs derived from the Mongol east, including dragons, phoenixes, and lotus blossoms. The dragon traditionally represented the emperor, the phoenix, when used in the same context, the empress, while the lotus was an emblem much valued by both Mongol royalty and the court. Once introduced, however, the phoenixes and lotus blossoms in particular were swiftly adopted by potters as decorative motifs with only a more general symbolic reference. The lotus could be easily accomodated in the Islamic tradition of vegetal and floral motifs, while the phoenix was assimilated with a Persian mythical bird called the *simurgh,* well known to all Persians from its heroic role in the *Shah-nameh,* or 'Book of Kings', the legends of the exploits of the mythical kings of ancient Iran.

The pottery of this period, wrongly named after Sultanabad in western Iran, displays three other novel elements: a generally grey tone, the shape of bowl used, and its external decoration. Each of these is derived from 'celadon' wares, the Chinese green-glazed stonewares, huge quantities of which were imported into Iran by sea in the fourteenth century. The grey tone reflects the rather dour colour scheme of the imports; the shape follows the common celadon shape, with its narrow foot and flaring, rounded sides; the decorative panelling follows the lotus-petal moulding which appears on the outside of so many Chinese examples.

Stone-paste; covered in a grey slip with ornament painted in white slip outlined in black under transparent glaze.
Diameter 20.7 cm, height 9.5 cm
1956.59 Barlow gift

Bib. Peter Morgan, Coloured-ground Sultanabad wares in the Ashmolean Museum, *Islamic Art in the Ashmolean Museum, Oxford Studies in Islamic Art* Vol. X (forthcoming).

Exterior of Chinese twelfth – thirteenth century celadon bowl, Ingram gift 1956.1289, (left), and exterior of 1956.59 (right).

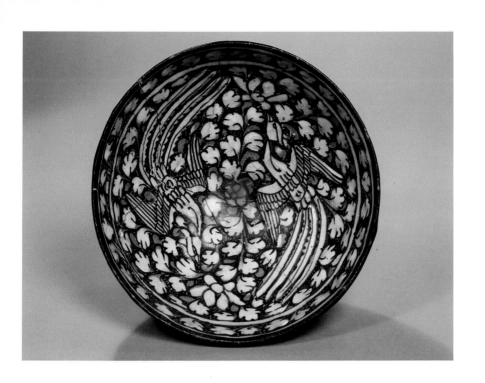

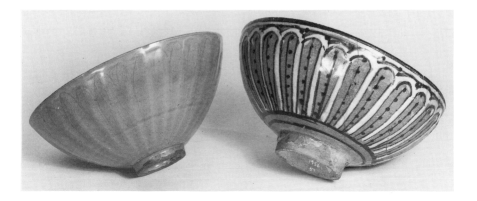

## 20–21 Camel
Syria or Iran thirteenth century
**Human-headed Jug**
Iran early fourteenth century

Despite the religious prohibition on the making of images, medieval Islamic taste shows a definite tendency towards zoomorphism – the transformation of functional objects into animal forms. Studies of medieval European bronze water-pouring vessels have shown that the lion, horseman and griffin forms most commonly encountered can be traced back to Near Eastern, Islamic metal prototypes. Surviving ceramic examples from the Islamic world include a group of three Syrian thirteenth century fountain-heads, a sphinx, a griffin and a horseman, and a number of pouring vessels from Iran, including oxen and seated lions. The small camel illustrated here appears to have been purely ornamental, as is a fine white-glazed figure of an ox from Syria (Victoria and Albert Museum) and a series of medieval Persian or Syrian ornamental figurines showing a woman and child. All are part of this same zoomorphic tradition, however.

The camel is highly iridescent through burial in the ground, but appears to have a blue and black design painted under the glaze. It is a Bactrian, two-humped camel, common in Central Asia, rather than the single-humped Arabian dromedary. The load appears to consist of neat lengths of wood, carefully tied together in bundles. They could be part of a Turcoman, white felt tent *(yurt)* on the move, and the attractive possibility then arises of a set of ornamental camels each laden with the different parts of such a *yurt*.

As common as complete animal forms for objects, was the use of human or animal heads for the mouths of jugs or ewers. The mouth of the jug (no. 21) is in human form, but could be the head of a sphinx. If so, it may well be designed to bring good luck to the owner, a role played by sphinxes throughout the early Islamic period. The inscription is illegible but would probably have suggested the repetitive good wishes commonly used to decorate early Islamic objects.

20. Stone-paste; decorated in black and blue under a transparent, highly iridescent turquoise glaze.
Height 10.8 cm, length 11.5 cm
1984.31 Lorna Yusof gift

21. Stone-paste; decorated in gold lustre over a blue glaze.
Height 21.5 cm, diameter *c.* 12 cm
1978.1675 Reitlinger gift

Bib. E.C. Dodd, On the origins of medieval *Dinanderie:* the equestrian statue in Islam, *Art Bulletin* vol. 51 (1969) pp. 220–232.

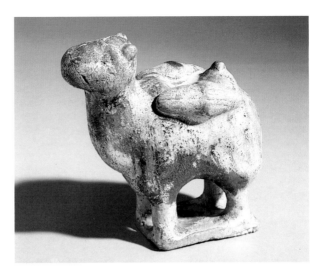

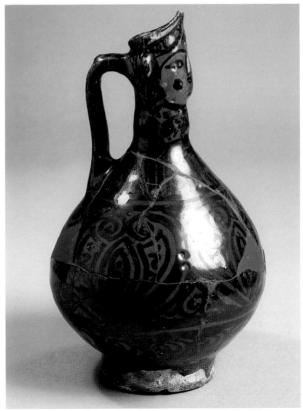

## 22    Underglaze-painted bowl
Syria twelfth – thirteenth century

The date of the introduction of underglaze-painting into Syria and Egypt, its origin and its early development, are much less clear than in the case of Iran (no. 10). It would seem, however, that by about 1200 AD the technique had become widespread. Two bowl forms are common, one, as in this example, hemispherical with a broad flat rim[1], the other truncated conical with a tall cylindrical foot (no. 25). The latter is so similar to a common Kashan shape of the early thirteenth century (no. 11) that there must be a link between Syria and Iran at this period, but which way the possible influence is moving is as yet uncertain. What is definite, however, is that both derive from a metalwork shape of which there is a notable inlaid bronze example in the name of an officer of the early thirteenth century ruler of Mosul (in northern Iraq), Badr al-Din Lu'lu'.

Syrian drawing on ceramics is much bolder than the drawing on contemporary Persian pots. Typical of the Syrian style are animals – hares, hunting dogs and deers – caught by the artist in an 'arrested' stance, one of their front paws raised, their head turned to the rear. Their two back legs are usually unnaturally lengthened, ending in glorious curving brush-strokes. Such animal drawing looks back to the Fatimid period (969–1172) in Egypt, when the legacy of classical realism could still be felt, and animals and birds were popular elements in art.

Stone-paste; decorated in blue and black under the glaze.
Diameter 27.5 cm, height 7.1 cm
1978.2183 Reitlinger gift

(a) Jar, stone-paste, decorated in black under blue glaze, Syria, late twelfth – early thirteenth century, Reitlinger gift 1978.2499, height 25.4 cm, diameter 17.8 cm

(b) Base of a bowl, stone-paste, decorated in black under colourless glaze, Syria, late twelfth – early thirteenth century, Reitlinger Gift 1978.2398, diameter 9.7 cm.

[1] For this shape, see bowl 1978.2193 under no. 25.

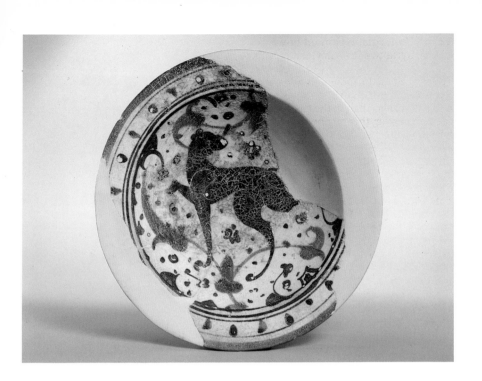

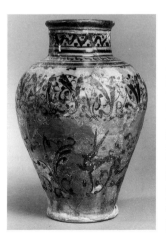

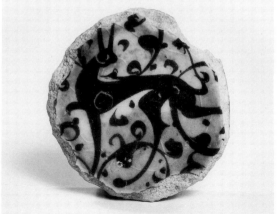

## 23–24 Two lustre bowls
### Syria twelfth – thirteenth century

The precise origins of the medieval Syrian lustre industry are uncertain, though it probably derives from the Fatimid Egyptian tradition. One school, associated with Tell Minis in northern Syria, is often characterised by figural designs; that associated with the city of Raqqa on the Euphrates, of which the two opposite are examples, tends towards vegetal patterns or calligraphy. In the latter case the lustre is often rather chocolate in tone. On these two bowls, the artists (or perhaps artist ?) have taken the Arabic word *al-surr*, 'happiness', and, combining brush strokes and imagination, have created two very similar, bold designs, each of which strongly suggests a peacock. The contrast between the two is quite marked, however, the one being tightly controlled and static in impact, the other far more fluid and fluent, almost with a life of its own.

23. Stone-paste; decorated in chocolate-coloured lustre.
Diameter of design 9.5 cm
1978.2175 Reitlinger gift

24. Stone-paste; decorated in gold-brown lustre.
Diameter of design 9 cm
X 3068

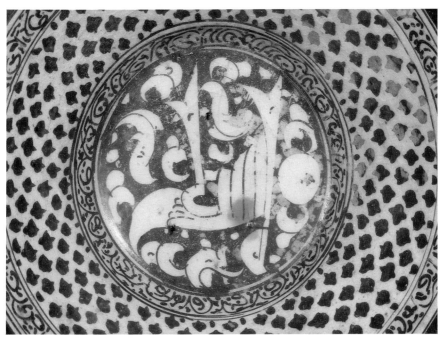

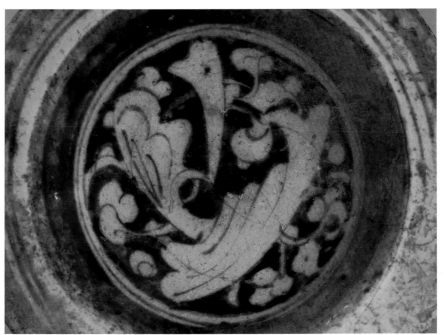

41

## 25  Underglaze-painted bowl
Syria twelfth – thirteenth century

This bowl is of the truncated conical form with a tall, cylindrical foot, mentioned above (no. 22). The pigment used for underglaze black has here produced, presumably by accident, a deep brownish colour. As with the figural designs (no. 22), the Syrian potter preferred a much bolder approach to that of his Persian contemporaries. The design on the bowl is made up of stylised and simplified leaf forms, which are paired to form a 'bracket' motif. These brackets are arranged in concentric circles in alternating colours, but, as with brick lays, the positions of the brackets are alternated in consecutive bands to provide visual variety and interest. The concentric design is balanced by a radial design, painted with a much thinner brush. This radial design is made up of eight lines, with a small heart-shaped panel alternating its position – either at the end of the line or two-thirds of the way along it. The pattern is also subtly reinforced by the positioning of the blue trefoils. The result may look simple, but it provides a brilliant example of how the tensions of a circular and concave bowl shape can be reconciled and harmonised into a totally satisfying unity. Contrast the design of the bowl below, in which the centrifugal tendency has been allowed to take over, and the viewer is left completely disconcerted.

Stone-paste; decorated in underglaze blue and brownish-black.
Diameter 22.2 cm, height 11 cm
1978.2196 Reitlinger gift

(a) Interior and (b) exterior of bowl, stone-paste, painted in underglaze black, Syrian twelfth – thirteenth century, 1978.2193 Reitlinger gift, diameter 25.3 cm, height 7.7 cm.

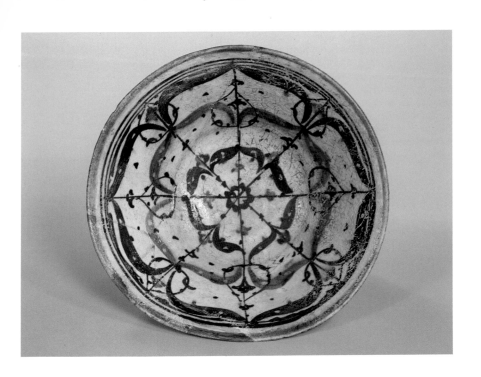

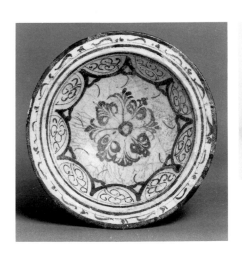

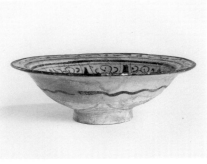

## 26    Underglaze-painted albarello
Syria late thirteenth century

'Albarello' is the name given to the drug or pharmaceutical jars of waisted form which became popular in Italy from the fifteenth century onwards. Inscriptions on extant Italian albarelli show that their primary use was in spice stores or hospital pharmacies[2]. The immediate origin of the form was Islamic, and one of the earliest extant examples, from thirteenth century Syria, now in the Ashmolean, is illustrated below. None of the surviving Islamic albarelli are inscribed, and the only piece of Islamic ceramic bearing the name of a substance[3] is a fourteenth century Syrian jar of a very different form. Hence, although they were almost certainly used for storage, it is impossible to be more precise about their likely contents. Ultimately the shape probably goes back to an Egyptian precious metal form of the Roman period. The Arabic inscription on the shoulder of this albarello makes no sense but appears to be derived from the inscriptions of good wishes so common on medieval Islamic objects (nos. 13–14). The verticality of the albarello is emphasised by the stripes on the body, while the band around the lower body balances the horizontal bands necessitated by the shoulder and short neck. The finely-painted underglaze black and the washes of underglaze blue provide a delightful combination of precision and movement for the design as a whole.

Stone-paste; decorated in underglaze blue and black; foot restored.
Diameter 15.5 cm, height 24.5 cm
1978.1683 Reitlinger gift

Albarello, stone-paste, painted in black under a transparent blue glaze, Syria c. 1200, diameter 8.7 cm, height 21.3 cm, 1956.178 Barlow gift.

[2] Examples of Italian albarelli may be seen in the Ashmolean Museum's collection of Maiolica; see also T. Wilson, *Maiolica* Ashmolean Museum (Oxford 1989) nos. 3 and 22.
[3] *naufar,* a water-lilly, and hence a medical preparation from the plant, see *Louisiana Revy* 27 no. 3 March 1987 no. 142.

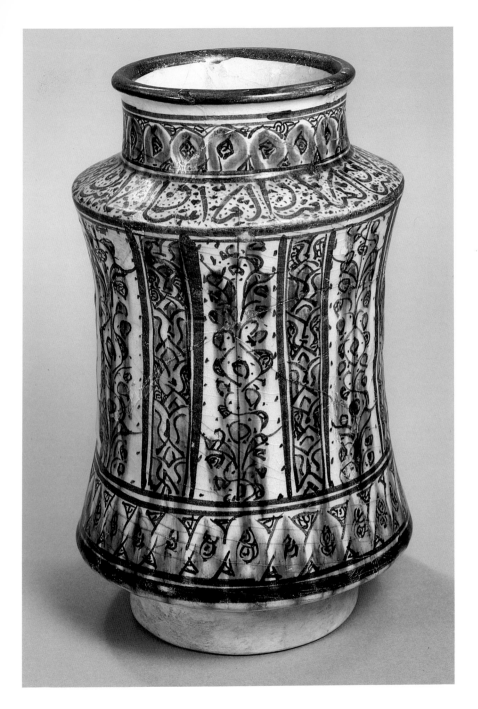

## 27 Underglaze-painted dish
Syria fifteenth century

The redevelopment of large areas of the old city of Damascus in the 1960's brought to light many hundreds of pieces of Chinese porcelain, imported into Syria from the late fourteenth century onwards, and cherished by their owners over the centuries. Among these porcelains are dishes which show very clearly the Chinese origin of both the blue-and-white colour scheme, and some of the plant forms, on contemporary Syrian vessels and tiles. Although precise dating of most blue-and-white Syrian objects may be difficult, the blue-and-white tiles which decorate the mausoleum and mosque of Ghars al-Din al-Khalil al-Tawrizi, vizier of Damascus, who died in 1430, show that the style was at its most popular in the second decade of the fifteenth century. Particular plant and leaf forms on the Tawrizi tiles in fact compare closely with those in the more densely decorated radiating panels on this dish, suggesting that a date of *circa* 1425 for the dish cannot be far from the truth. Typically Syrian are the form of dish (a shallower version of the thirteenth century Syrian bowl form illustrated elsewhere), and the pattern on the rim, both of which are found in contemporary sgraffito wares. More unusual on Syrian blue-and-white is the turquoise glaze. Like the geometric layout, however, it recalls yet again the way medieval Islamic potters were keen to move away from slavish copies of Chinese imports to designs which incorporated their own cultural traditions and artistic taste.

In Iran the adoption of blue-and-white was destined to have a long and productive future. In the early sixteenth century, however, Syria became a mere province of the vast Ottoman Turkish empire. As a cultural backwater, its ceramics henceforward played second fiddle to the rich polychrome wares of Iznik, unable to emulate them in either design or colour.

Stone-paste; decorated in blue under a turquoise glaze.
Diameter 30.2 cm, height 8.5 cm
1978.1608 Reitlinger gift

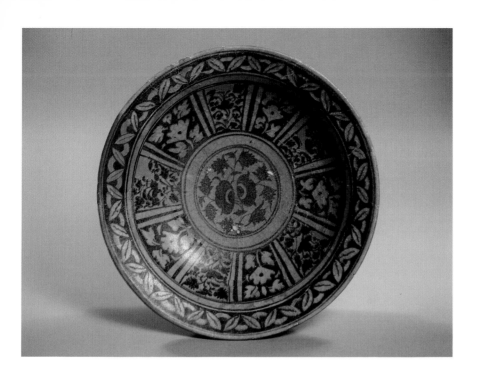

## 28    Lustre dish
Spain (Manises) late fifteenth century

When exactly lustre was first produced in Spain is unknown, but it is certain that it was an extremely popular commodity from the thirteenth century until relatively recent times. Prior to the Christian reconquest of southern Spain, lustre was manufactured in Malaga, Murcia and Almeria, and possibly in Granada too. In the fourteenth century, however, Moorish potters were lured northwards by Christian patrons, and by 1400, under the patronage of the local de Buyl family, the pottery at Manises, near Valencia, had superceded its main rival, Malaga, in lustre manufacture.

In these so-called Hispano-Moresque wares, the lustre, often combined with cobalt blue in the glaze, is painted onto a tin-glaze. All three elements result from early Islamic technological developments (nos. 1–3), and blue and lustre was a common combination in both Syria and Persia in the thirteenth century. Quantities of lustre wares from Manises were exported to Italy in the fifteenth centuries, where the tin-glazes, designs and colour schemes were key elements in the development of the first great decorative ceramics of Europe, Maiolica. The technique of lustre itself was also exported, and Deruta, near Perugia, soon became the major centre for Italian lustre ware[4].

The design on this splendid dish illustrates the Muslim and Christian strands to the fifteenth century Spanish industry. The coat-of-arms of the Christian Kingdom of Castile takes pride of place, and Christian belief is emphasised by the fishes on the reverse, each one a symbol of Christ, and the three together a symbol of the Trinity. (The initial letters of the Greek words for 'Jesus Christ, Son of God, Saviour', make up the Greek word for 'fish', *ichthus*.) However, the Muslim background of the craftsman who made the dish is clear from the magnificent leaves which form such a throbbing ground to the shield. These are directly related to the half-palmettes which decorate fourteenth century Malagan work, in particular the Jerez vase in the Museo Arqueologico, Madrid, and show the continuing vitality of the Islamic tradition in Hispano-Moresque work.

Earthenware; tin-glaze; painted in blue and lustre.
Diameter 43.3 cm, height 6.0 cm
Manises, first half of the fifteenth century
Department of Western Art, C 354 Fortnum collection

[4] See T. Wilson, *Maiolica* Ashmolean Museum (Oxford 1989). The word *maiolica* may itself be derived from the Spanish name for lustre, *obra de malequa.*

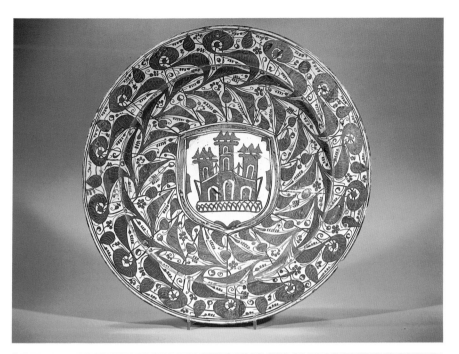

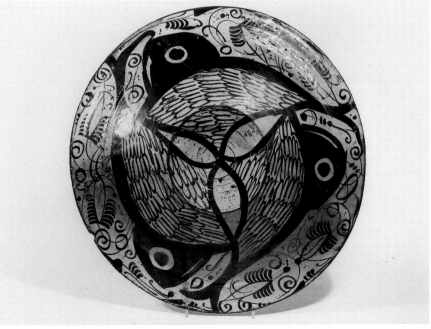

## 29–30 Two blue-and-white bowls
### Iran fifteenth century

These two bowls vividly illustrate the transition between the decorative styles and motifs of fourteenth century Persian ceramics and those current on ceramics produced under the Safavid dynasty in the sixteenth–seventeenth century. The traditional elements are most clearly seen on the second, where the design is of a six-pointed star within two other six-pointed stars, the whole framed by a (fragmentary) Persian inscription. The 'fish-scale' filler pattern and the trefoils appear to be based on fifteenth century metalwork. The shape, like the colour scheme, however, was introduced into the Islamic world from China in the late fourteenth century, and the decoration on the outside of the rim is a simplified version of a common fourteenth century Chinese border design.

In the upper bowl the traditional elements are far fewer. The central phoenix continues the 'Sultanabad' style illustrated above (no. 19), though even here of course there is a Far Eastern source for the creature. Traditionalism emerges too in the way the whole design forms a circle within a square within a cross-shape, the latter with very wide, round-ended arms: far more geometric in concept than contemporary Chinese designs. But the Chinese elements are otherwise very strong: the peonies, the border patterns, the band of lappets on the outside, the blue and white colour scheme and the shape, all derive from late fourteenth century imports. In Iran, from the fifteenth century onwards, the potters had great difficulty withstanding the impact of Chinese blue and white porcelains, though they never completely forgot their Islamic heritage, the latter tradition surfacing at regular intervals alongside the imported motifs and designs (see nos. 36–37).

28. Stone-paste; decorated in underglaze blue.
Diameter 17.2 cm, height 8.2 cm
1956.114 Barlow gift

30. Stone-paste; decorated in underglaze blue.
Diameter 24 cm, height 9.8 cm
1978.1593 Reitlinger gift

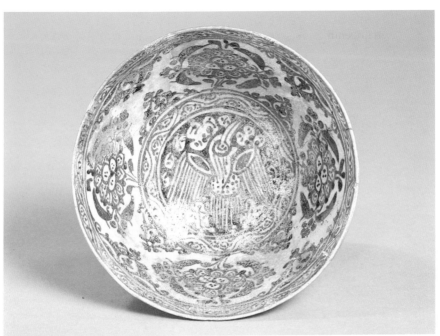

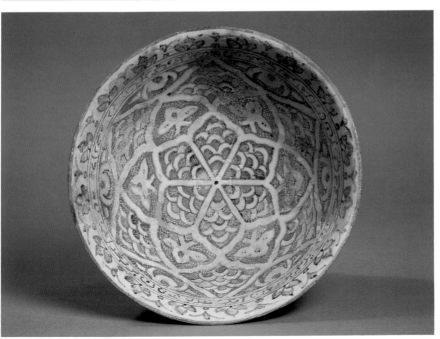

51

## 31 Blue and white dish
Iran early sixteenth century

Chinese porcelains were held in high esteem in the courts of the fifteenth century Islamic rulers of the Near East. For example, in the second half of the century, documents reveal a steady succession of gifts of Chinese porcelain from the Mamluk Sultans of Egypt and Syria to the Doges of Venice, or to other important European figures. And when the Ottomans captured Cairo in 1517 the thousand camels used to transport the booty to Istanbul must have carried many tens, if not hundreds, of pieces of porcelain, for a contemporary chronicler records porcelains high on the list, fourth only to gold, silver and weapons, in order of importance. Turning to Chinese porcelains at contemporary Persian courts, an Ottoman register records that sixty-four pieces were found in the Hasht Behesht palace and elsewhere in Tabriz, the north-west Persian capital of the Turcoman dynasty, after its capture by Selim I in 1514. And indeed such objects are frequently shown in Persian miniature paintings of the day, either in day to day use, or housed in special rooms to show off to important guests.

The Persian dish illustrated here was probably made in Tabriz early in the sixteenth century, and must have been based on Chinese porcelains seen by the potter in the local bazaar, on their way perhaps to the royal treasury. The Chinese motifs copied by the potter are the rock-and-wave border, the chrysanthemum sprays in the cavetto, and the lotus flower with coiled stem and leaves around it. Chinese potters sometimes used cloud-collars to form a star shape to outline the centre of a dish, but, typically, the Islamic potter has introduced a much stronger geometric flavour to the design through the use of a blue arcade of eight arches, which forces the white, eight-pointed star which it encloses and defines onto the viewer's attention. The tension between this arcade, the circular stem within it, and the central lotus flower, on the one hand, and the spiral stem breaking into three, on the other, provides the extraordinary drama of the dish.

Stone-paste; decorated in underglaze blue.
Height 8 cm, diameter 42 cm
1978.1484 Reitlinger gift

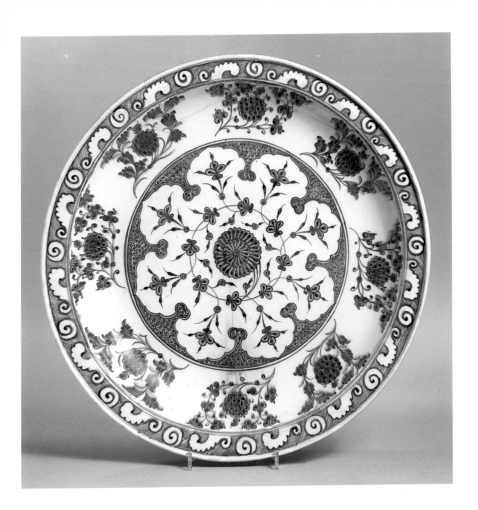

## 32–33 Elephant kendi and jar
Iran early seventeenth century

The form of this creature is taken straight from Chinese, Ming, porcelain. The Topkapi Treasury contains no less than ten late sixteenth century Chinese elephant kendis, while there is also an example in the collection of Chinese porcelain presented to the Ardabil Shrine by Shah Abbas I in 1617. The Chinese kendi derives from the Buddhist drinking vessel known as a *kundi*, and elephant kendis were presumably exported westwards in the late sixteenth century in the expectation that they would be popular with Buddhist taste in the Indian subcontinent. In Iran and Turkey they seem to have made no impact on local drinking habits, and were probably used for purely decorative purposes.

On the other hand, Persian potters felt perfectly at ease decorating an object in a Chinese manner without necessarily adopting a Chinese shape. In the second piece, the potter has used the Chinese pictorial tradition and Chinese patterns on an object derived from a Persian metalwork bowl with a lid. However, the potter has transformed the object into a jar by sticking lid to body – hence the double rim around the shoulder, and removing the inside of the handle to create a narrow mouth. Shapes used by the potters, whatever their origin, happily underwent modification without reference to the originals. Thus, this jar shape became increasingly curvilinear as the century progressed, and was eventually fluid enough to lend itself to the more vertically-orientated, flower and plant designs of the lustre potters, who duly adopted it (see below).

32. Stone-paste; decorated in underglaze blue and black.
Height 21.5 cm, length 15.2 cm
1978.1700 Reitlinger gift

Bib. R. Krahl, J. Ayers, *Chinese Ceramics in the Topkapi Saray Museum* (London 1986) Vol. 2 nos. 1294–5.

33. Stone-paste; decorated in underglaze blue and dark blue.
Diameter 18.4 cm, height 12 cm
1978.1722 Reitlinger gift

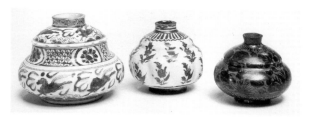

Three stone-paste jars with underglaze-painting or lustre decoration, Iran seventeenth or early eighteenth century. 1978.1718, 1719, 1720, Reitlinger gift, heights 10 cm, 11 cm, and 11.5 cm

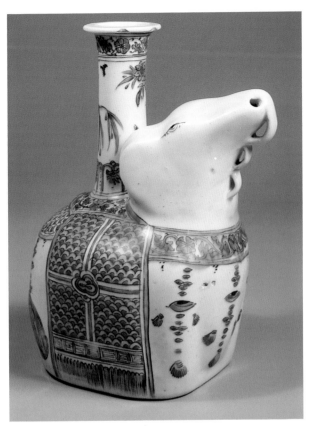

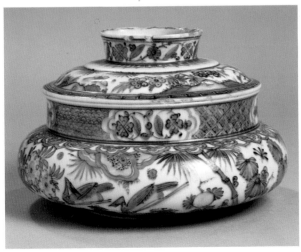

## 34–35 Lustre wine bottle and plate
Iran late seventeenth century

By the middle of the fourteenth century lustre production had gone into serious decline in Iran. Two objects and a small number of inscription tiles and tombstones ranging in date from 1418–1560 are all the evidence of its survival prior to *c*. 1650. Then there appears to have been something like a renaissance, with objects decorated in lustre becoming common once more, and the quality of workmanship often of a very high standard.

Both in colour of lustre, and in design, there are major changes from earlier traditions. The bright, golden lustre now gives off a rich purple reflection, which adds to the luxurious impact of the finest pieces. The decoration includes animals (here an antelope and two foxes), birds, cypress trees and a variety of flowers, densely painted, but in a delicate, naturalistic style. These almost certainly derive from the gold-painted, marginal illuminations of contemporary books, while the more formal arabesques in cartouches around the rim of the plate illustrated here can be imagined framing frontispieces or illustrations in such works. Once again we see how innovation in Islamic ceramic design was so often due to the influence of the manuscript illuminators (cf. nos. 13–14).

34. Bottle; stone-paste; decorated in gold lustre over dark blue glaze.
Diameter *c*. 14 cm, height 28 cm
X 3080 Fortnum gift

35. Plate; stone-paste; decorated in gold lustre.
Diameter 21.5 cm, height 4.5 cm
X 1207 Fortnum gift

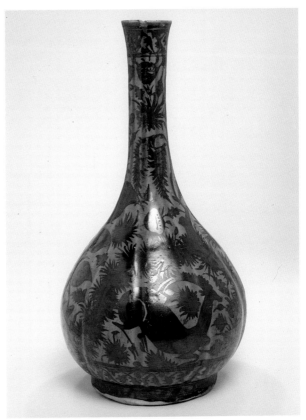

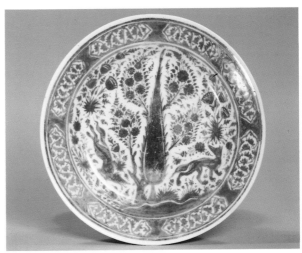

57

## 36    Dish
Iran early eighteenth century

This late example of Safavid blue and white shows vividly the way different styles and traditions were synthesised by the craftsmen-potters of the day. The stream with the goose standing beside it and the flowering prunus tree come straight from Chinese blue and white porcelain designs, as does the upper landscape with birds, cloud scrolls and a single lotus blossom. So too the brownish rim, which is commonly found on seventeenth century Chinese porcelain. The central cypress and the irises on the right hand side of the dish are taken from the lustre tradition (nos. 34–35), and derive ultimately from book illumination. The carnations, on the left, are rare items on Persian blue and white. However they do appear on contemporary Kirman polychrome wares, in which they are used alongside a red – unique in Persian ceramics of the period. They may well have been introduced, therefore, by a potter who was acquainted with Iznik ceramics, on which, combined with a strong sealing-wax red, they are a standard floral element from the second quarter of the sixteenth century onwards (no. 47).

Stone-paste; underglaze-painted decoration.
Diameter 47.5 cm, height 8.2–9.7 cm
1986.50 Pinder-Wilson gift

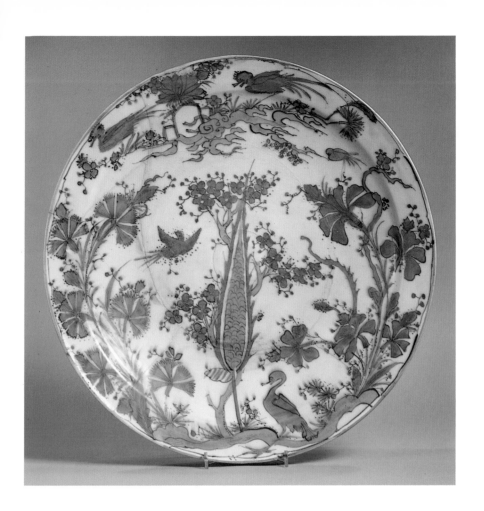

## 37  Dish
Iran early eighteenth century

The synthesis involved in the design of this splendid dish is not quite so complex as that on the previous one (no. 36), but it provides an interesting and impressive variation on the same theme. Here the two pheasants amid peonies in the central roundel are copied painstakingly from imported Chinese blue and white designs, while the faint incised patterns in the points of the inner star derive from the moulded designs used on sixteenth century Chinese ceramics. The two eight-pointed star designs which surround them, however, are part of the inherited Islamic culture of the Persian potter and the traditional Islamic taste for geometric patterns. In few other Safavid objects are they so successfully contrasted and combined.

Stone-paste; decorated with incised designs and underglaze blue.
Diameter 46 cm, height 7.7 cm
1978.2169 Reitlinger gift

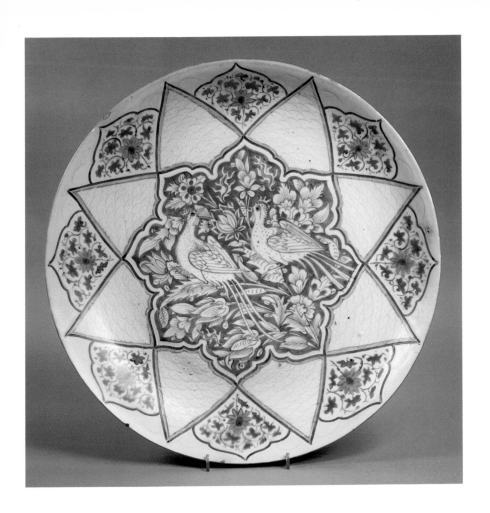

## 38–39 Two kalians
### Iran late seventeenth or early eighteenth century

Tobacco was introduced into the Islamic world by Europeans, who had themselves first encountered it in the Americas. The method adopted for smoking tobacco in the Near East was, however, different from that adopted in Europe, for the Persian kalian (in the Arab world a hookah and in India a narghile) is a type of pipe which uses a metal or ceramic vase containing water. The tobacco is burnt in a holder above the vase, and the smoke is drawn downwards through the water by sucking a hollow rod or tube attached to the shoulder of the vase. Rosewater is often used in the vase to sweeten the flavour.

The two commonest forms in Persian soft-paste procelain are the sphere and the pear-shaped bottle. The pear-shaped kalian illustrated is decorated with rocks, pines and waterfalls in the Transitional Ming style of 1620–1683. Very little Chinese porcelain was exported at this period, and Persian copies are very rare. The spherical kalian is an example of the polychrome soft-paste porcelains probably made in Kirman at this period. Late seventeenth century travellers, and the records of the Dutch and British East India Companies, all affirm Kirman as the producer of the finest Persian ceramics of the day: its geographical location in central southern Iran meant that it was well placed for export to Bandar Abbas, a port at the eastern end of the coast of the Persian Gulf, and the Indian Ocean. The finely painted leaves and flowers in orange-red and olive-green suggest an origin in book illumination (cf. no. 34–35), while the leaves and stems in underglaze blue are in a very decadent and totally contrasting style.

38. Pear-shaped kalian; stone-paste; underglaze painting in black and shades of blue.
Diameter c. 16.5 cm, height 28 cm
1978.1703 Reitlinger gift

39. Spherical kalian; stone-paste; underglaze painting in blue, red. and sage green.
Diameter c. 18 cm
1978.1712 Reitlinger gift

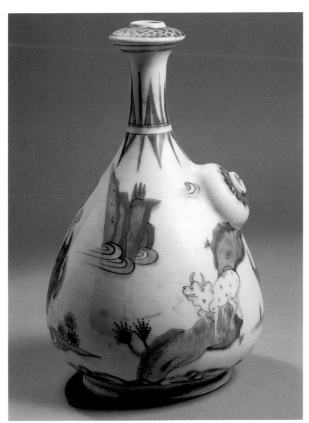

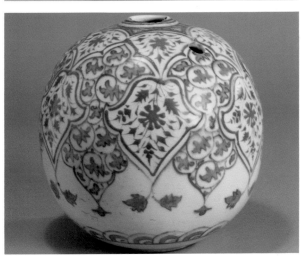

## 40-41 Jug and small bowl
Iran late seventeenth or early eighteenth century

These two objects are of a type usually termed 'Gombroon ware'. Gombroon was the old name for the port of Bandar Abbas. Here the Dutch East India Company had a trading-station, and from Gombroon quantities of Persian soft-paste porcelain were shipped to Europe. Although the bulk of exported ceramics were probably blue and white, the term 'Gombroon ware' is helpful in distinguishing this group, in which white so obviously dominates.

Both these objects illustrate a relatively plain aesthetic which is unusual in Islamic ceramics. The origin of the shape is uncertain, but the most likely explanation is that it derives from late seventeenth – early eighteenth century Famille Verte Chinese ewers, of which there are two fine examples in the Topkapi Saray in Istanbul. Such ewers were themselves probably copied from Islamic metalwork prototypes. Moulded designs on blue and white could well have provided the inspiration for the underglaze incised patterning.

The bowl on the other hand shows more local taste. The form, with a moulded domical centre, is part of an age-old tradition of *phialae,* small bowls used for pouring water, known from Greek and Achaemenid examples, and still used in the Islamic world today. The piercing of the sides of the bowl is probably the Persian potter's attempt to emulate the translucency of Chinese porcelain, and may well be the source of the rice-pattern used by the Chinese potters of the eighteenth and nineteenth century. The three stems of trefoils illustrate the typical desire of the Islamic potter for colour and design, here exquisitely rendered, and carefully balanced by the groups of black dots on the rim.

40. Ewer; stone-paste; incised decoration.
Diameter *c.* 13.5 cm, height 21.5 cm
X 3035 Brangwyn gift

41. Bowl; stone-paste; pierced decoration and underglaze painting in black.
Diameter 15.3 cm, height 5.1 cm
1978.1765 Reitlinger gift

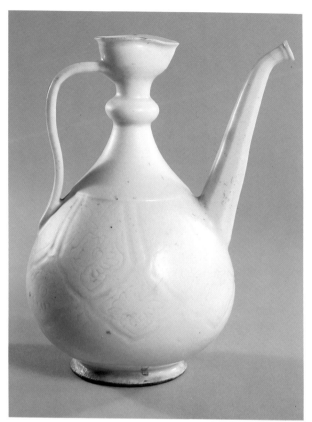

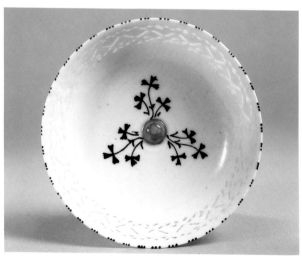

## 42    Dish
Turkey (Iznik) *c.*1530

Sultan Selim the Grim's conquest of Tabriz in 1514, and of Damascus and Cairo in 1517, led to the Ottoman acquisition of huge quantities of Chinese porcelain, subsequently no doubt stored at Topkapi Palace in Istanbul. The result was that the Iznik potters had access to a whole range of designs which they had never previously encountered. Among the most popular with the Iznik potters was the early fifteenth century Chinese design of three bunches of grapes amid vine leaves (see photo below). In the Ming models the design was usually surrounded by twelve sprays of flowers in the cavetto, and a wave-and-rock pattern border.

The Iznik derivatives, though very similar, are by no means identical. In the first place, the central grape design is often reversed, indicating the use of stencils in the copying process. Secondly, the Iznik potters felt free to use a border which, though similar to that on the Ming dishes, was actually derived from a Chinese fourteenth century (Yuan) design. Thirdly, the Chinese dishes have moulded panels around the cavetto, so that the twelve floral sprays are regularly spaced. The Iznik potter used a smooth cavetto and, painting by eye, felt free to vary the number of sprays according to his taste. Finally, the Iznik potter was not bound by the limitations of high-fired porcelains, in particular the restriction of the colour palette to cobalt blue. Instead he was free not only to vary the tones and strengths of the blue itself but also to add turquoise. The result is a design with a lightness and spontaneity quite different from the Chinese prototype.

Stone-paste; underglaze painting in blue and turquoise.
Diameter 41 cm, height 7.7 cm
1978.1470 Reitlinger gift

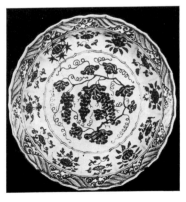

Blue and white porcelain dish, China early fifteenth century, Iran Bastan Museum, Tehran no. 29.55 (after J.A. Pope, *Chinese porcelains from the Ardebil Shrine* (Washington 1956), pl. 37

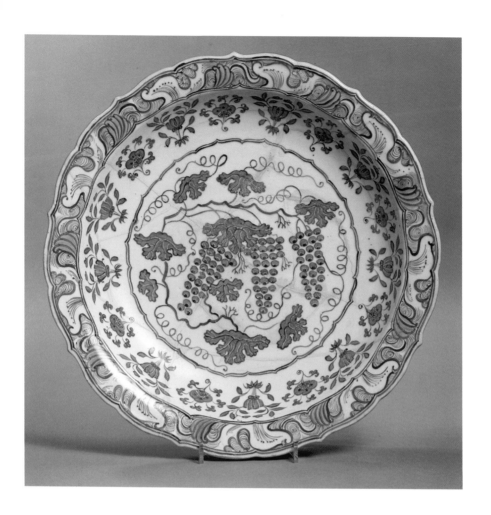

## 43 Tondino dish
### Turkey (Iznik) c.1535–45

Although documented European interest in Iznik ceramics is so scarce (nos. 46–47), there was evidently a lively interchange of objects and, to a lesser extent, ideas, through regular Mediterranean trade. The Ottoman court also showed a continuing interest in Italian art. Thus, for example, from 1478–81 Costanzo da Ferrara worked in Istanbul as a medallist, and Michelangelo, even though he did not take up the invitations, was twice invited to Istanbul, once in 1506 to build a bridge over the Golden Horn and again in 1519 to paint for Sultan Selim. It is no surprise therefore to find the occasional influence of Italy in the products of Iznik. A dish in the Victoria and Albert Museum has a medallion portrait of a Turkish youth in the centre, following the fashion in Italian maiolica, and this Ashmolean piece, with its wide flat rim and small bowl-shaped recess, is a 'tondino' dish, characteristic of the taste of Italy in the early 16th century. The design on the other hand is purely Ottoman. Objects in this style have traditionally been known as 'Golden Horn' ware, but the design has recently been more accurately named as the '*Tugrakes* spiral style'. For it is derived from the illuminated spiral scroll used on royal documents as a background design for the Sultan's *tughra*, or imperial monogram. In particular, it relates very closely to that on a document dating from the reign of Sultan Suleyman the Magnificent, c. 1523–36. Here, therefore, we have a ceramic design which directly reflects the taste of the imperial court.

Stone-paste; underglaze blue decoration.
Diameter 24.5 cm, height 5 cm
X 3274 Fortnum gift

Bib. N. Atasoy and J. Raby, *Iznik. The Pottery of Ottoman Turkey* (London 1989) pp. 108–113.

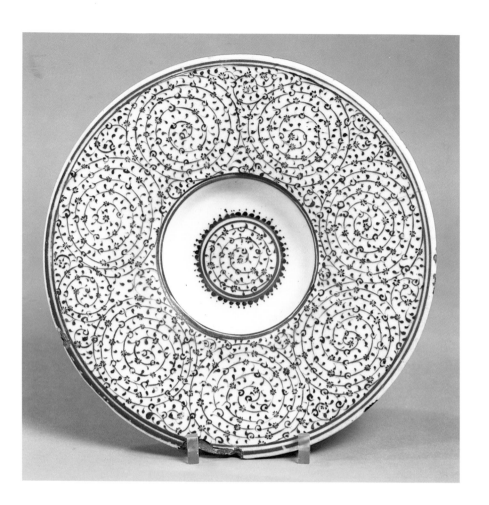

## 44–45 Dish and carafe
Turkey (Iznik) c.1545–50

Flowers were as popular among the Ottomans as they are in England today. In 1554, for example, the Holy Roman Emperor's Ambassador to the Ottomans records how visiting Janissaries would offer him a bunch of hyacinths or narcissi. (In fact it was this same Ambassador, Augier Ghislain de Busbecq, who introduced tulips into Europe.) The appearance of recognisable species of flowers on Iznik ceramics was due to the rise to eminence of one particular artist, Kara Memi, at the court of Suleyman the Magnificent. Kara Memi transformed Ottoman illumination by introducing naturalistic flowers, such as tulips, roses, hyacinths and carnations, to replace the traditional, stylised, Islamic floral motifs and arabesques.

Although some traditional elements were still retained, like the peony in this dish, the naturalistic flower designs clearly captured the imagination of the Iznik potters. First making their appearance in the 1540's, they were accompanied by a new colour scheme. To the blue and turquoise of the preceeding decade were added a soft sage-green, a manganese-purple, and a soft greenish-black for outlines. Experiments were made with colouring the background, and a fish-scale pattern introduced to help alleviate the monotony of a large area of single colour. The final phase (nos. 46–47) was the introduction of a new, vibrant colour – 'sealing-wax' red.

44. Dish; stone-paste; underglaze painting in blue, turquoise, purple and green.
Diameter 28.8 cm, height 3.9 cm
X 3277 Fortnum gift

45. Carafe; stone-paste; underglaze painting in blue, turquoise, purple and green.
Diameter c. 14.5 cm, height 25.0 cm
X 3272 Fortnum gift

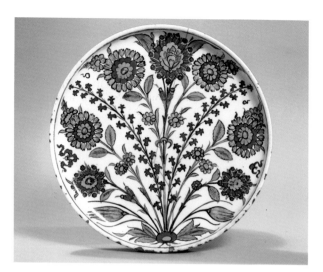

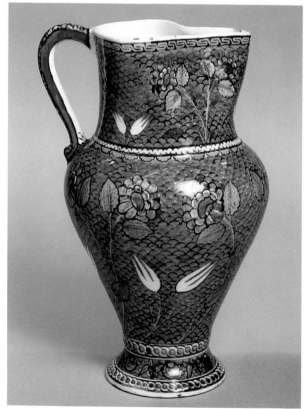

## 46–47 Two small dishes with a European coat-of-arms
Turkey (Iznik) *c*.1570

Although the colours and designs of Iznik pottery have held a special attraction for the European eye for the last century and a half, documented evidence of their interest in the sixteenth century is surprisingly scanty. The only literary evidence seems to be a suggestion by the Habsburg Ambassador in Istanbul in 1577 that the Bishop of Salzburg might wish to order some Iznik tiles, but no such order is known to have been placed. All the more important, therefore, is the set of dishes emblazoned with a European coat-of-arms. Of this set, ten pieces are known to survive, and two are in the Ashmolean.

Whose coat-of-arms it actually is, is not absolutely certain. The most likely candidate, however, seems to be a member of the Spingarolli de Dessa family of Dalmatia (northern Yugoslavia), whose blazon fits that on the Iznik dishes most precisely. The Dalmatian city of Ragusa (modern Dubrovnik) had a flourishing trade with the Levant in the fifteenth and sixteenth centuries, and an order for Iznik dishes from one of its merchants would be perfectly appropriate.

In the twentieth century, components of a dinner service are expected to be in an identical pattern. It is interesting to see that the Iznik dishes, though they are all decorated with a spray of flowers, bear different floral arrangements. For example, whereas in these two examples the blazon is set against the central flower stems, on some pieces it is framed by them, making a quite different visual impact.

46. Stone-paste; underglaze painting in blue, red, green and black.
Diameter 20 cm, height 2.7 cm
X 3268 Fortnum gift

47. Stone-paste; underglaze painting in blue, red, green and black.
Diameter 21.5 cm, height 2.8 cm
Department of Western Art, C 324 Fortnum collection

Bib. N. Atasoy and J. Raby, *Iznik. The Pottery of Ottoman Turkey* (London 1989) pp. 264–6.

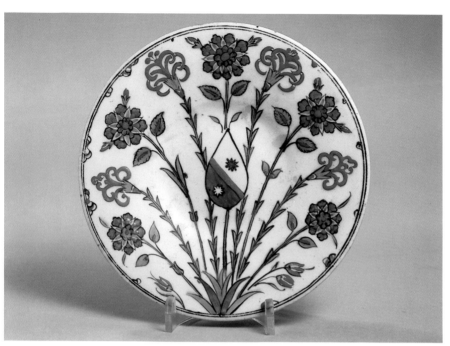

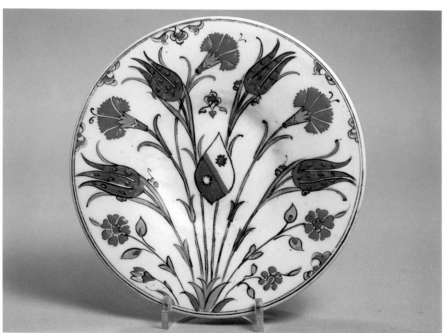

## 48    Dish
Turkey (Iznik) *c.*1575

The naturalistic painting of tulips, carnations and other flowers never completely ousted the earlier designs and colour schemes of Iznik ceramics, as this delightful dish shows. The combination of blue and white, the large peony blooms, and the lotus-panel arcading all derive from Chinese art, which had so influenced designs in the second quarter of the century. To this rich artistic source the potters periodically returned for inspiration.

The overall impression is of fluid and free movement of stems and ears of wheat. In truth, however, the design has been very carefully planned. At its heart is a pointed oval shape formed by the two main stems of the plant. The two large peony blooms balance one another on either side of this oval, and the smaller peony above is balanced by the ear of wheat next to it. The fluidity of the design is in fact due largely to the curving entry of the main stem and the positioning and sizes of the four ears of wheat in front of, and either side of it: a very subtle and very charming piece of design.

Historically, this dish and others like it are of considerable interest. For in the 1570's Francesco de' Medici, Duke of Tuscany, was experimenting with making imitation porcelain. In 1575 the Venetian Ambassador to Florence wrote that the Duke 'has equalled its quality – its transparency, hardness, lightness and delicacy; it has taken him ten years to discover the secret, but a Levantine showed him the way to success'. The fact that several pieces of Medici porcelain have stylistic affinities to the wheatsheaf style, and that technically both Medici porcelain and Iznik use a quartz or sand body with a small proportion of clay, suggests that the Levantine might well have come from Iznik itself, bringing with him the secrets of the Iznik potteries.

Stone-paste; underglaze painting in blue.
Diameter 35.5 cm, height 7.1 cm
1978.1455 Reitlinger gift

Bib. N. Atasoy and J. Raby, *Iznik. The Pottery of Ottoman Turkey* (London 1989) p. 268.

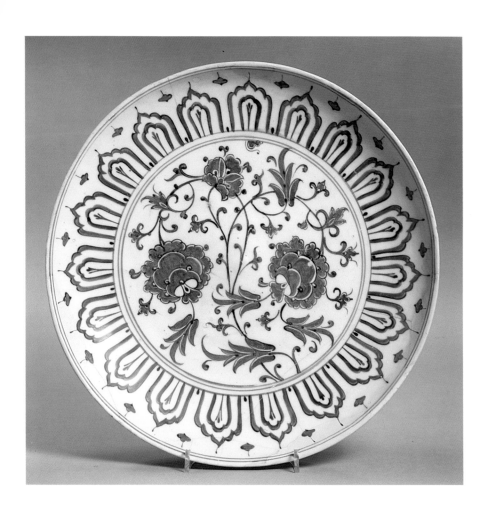

# Author's note

The Ashmolean Museum's collection of Islamic ceramics, upon which this book is based, owes its existence to three particular benefactors. Charles Drury Fortnum (1820–1899)[1], a member of the family who owned Fortnum and Mason, the famous grocers in Piccadilly, was a gentleman connoisseur. His collections ranged widely in both material and date, but among them were a small number of sixteenth – seventeenth century Turkish and Persian soft-paste porcelains, and some Hispano-Moresque pieces, objects which accorded with his taste for Renaissance European ceramics.

Sir Alan Barlow (1881–1968)[2], on the other hand, was a civil servant, whose taste for Islamic ceramics was much more wide-ranging. He donated most of his Islamic collection to the University in 1956; his other passion, his collection of Chinese ceramics, he bequeathed to Sussex University.

Third, and most important, was Gerald Reitlinger (1900–1978)[3], artist, traveller, writer, connoisseur. Alongside an extraordinary range of Far Eastern and European ceramics, Reitlinger amassed some 750 pieces of Islamic pottery. He also brought back large quantities of archaeological material from expeditions to Iraq, and wrote a number of important articles.

The debt of the University to these three men is profound. Not only do their objects make up the important display of Islamic ceramics in the Reitlinger Gallery, they also provide the Museum with a unique study collection: on these objects university students regularly focus their research, and on them future connoisseurship is being steadily built.

---

[1] See T. Wilson, *Maiolica*, Ashmolean Museum (Oxford 1989) pp. 4–7.
[2] See J.W. Allan, Medieval Middle Eastern Pottery, Ashmolean Museum (Oxford 1971) p. vii..
[3] See *Eastern Ceramics and other works of art from the collection of Gerald Reitlinger*, Ashmolean Museum (London 1981) pp. 9–15, 99–101.

# Glossary

**Alkaline glaze:** a glaze fluxed with alkali e.g. soda or potash.

**Earthenware:** a ceramic body made from clay maturing at $c$.850–1200 C.

**Flux:** a substance which determines the melting and fusion point of a glaze e.g. lead oxide.

**Frit:** a pulverised, insoluble glass formed by the fusion (or fritting) of the various materials being used.

**Glaze:** vitreous (glassy) coating applied to the surface of a pot to make it impermeable or for decorative effect.

**Kufic:** geometric form of Arabic script.

**Lead glaze:** a glaze fluxed with lead oxide.

**Lustre:** a metallic sheen on the surface of a glaze used for its decorative effect (see no. 3).

**Maiolica:** tin-glazed earthenware in the tradition of the Italian Renaissance.

**Minai ware:** pottery decorated in overglaze colours (see nos. 13–14).

**Porcelain:** a ceramic body made of felspathic clay maturing at $c$.1350–1400 C.

**Sgraffito ware:** ceramics decorated with incised designs under the glaze (see no. 5).

**Slip:** a semi-fluid coloured clay used either for coating a pot or decorating it before glazing.

**Stone-paste:** an artificial ceramic body made, according to the medieval Persian potter Abu'l-Qasim Kashani, from ten parts of ground quartz, one part of ground glass (alkaline) frit and one part of fine white clay. The stone-paste body of sixteenth century Iznik pottery also contained lead-rich frit.

**Stoneware:** a ceramic body made from clay, harder and heavier than earthenware, maturing at $c$.1200–1300 C.

**Tin glaze:** a glaze (lead- or alkaline-fluxed) opacified with tin oxide.

# Select bibliography

J.W. Allan, *Medieval Middle Eastern Pottery*, Ashmolean Museum 1971.

J.W. Allan, Abu'l-Qasim's treatise on ceramics, *Iran* Vol. 11 (1973) pp. 111–120.

A. Caiger-Smith, *Tin-Glaze Pottery*, London 1973.

A. Caiger-Smith, *Lustre Pottery*, London 1985.

*Eastern Ceramics and other works of art from the collection of Gerald Reitlinger*, Ashmolean Museum 1981.

G. Fehérvári, *Islamic Pottery. A comprehensive study based on the Barlow Collection*, London 1973.

A. Lane, *Early Islamic Pottery*, London 1947.

A. Lane, *Later Islamic Pottery*, London 1957.

V. Porter, *Medieval Syrian Pottery*, Ashmolean Museum 1981.

J. Soustiel, *La céramique islamique*, Paris 1985.

Oliver Watson, *Persian Lustre Ware*, London 1985.

I am very grateful to Mrs. Geraldine Beasley for the photographs of the various pieces illustrated, which are all her work.

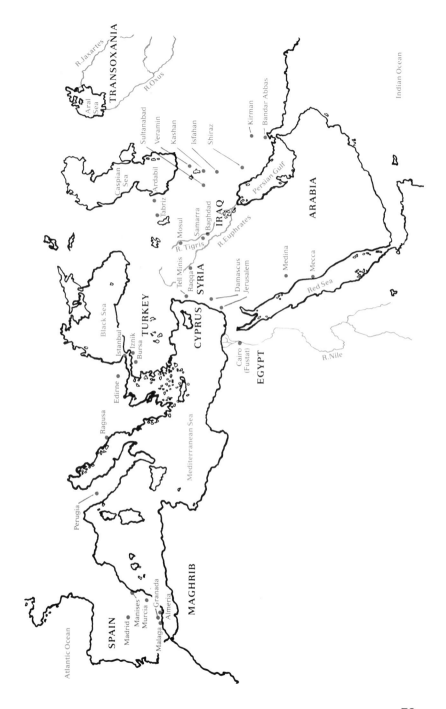

TRANSOXANIA

R.Jaxartes

R.Oxus

Aral
Sea

Indian Ocean

Kirman
Bandar-Abbas

Sultanabad
Veramin
Kashan
Isfahan
Shiraz

Caspian
Sea

Ardabil

Persian Gulf

ARABIA

Tabriz

Mosul
Samarra
Baghdad

IRAQ

R. Tigris
R.Euphrates

Tell Minis

Medina

Mecca

Raqqa
SYRIA

Damascus
Jerusalem

Red Sea

Black Sea

TURKEY

Istanbul
Iznik
Bursa

CYPRUS

Edirne

Cairo
(Fustat)

EGYPT

R.Nile

Ragusa

Mediterranean Sea

Perugia

Atlantic Ocean

MAGHRIB

SPAIN

Madrid
Manises
Murcia
Malaga
Granada
Almeria